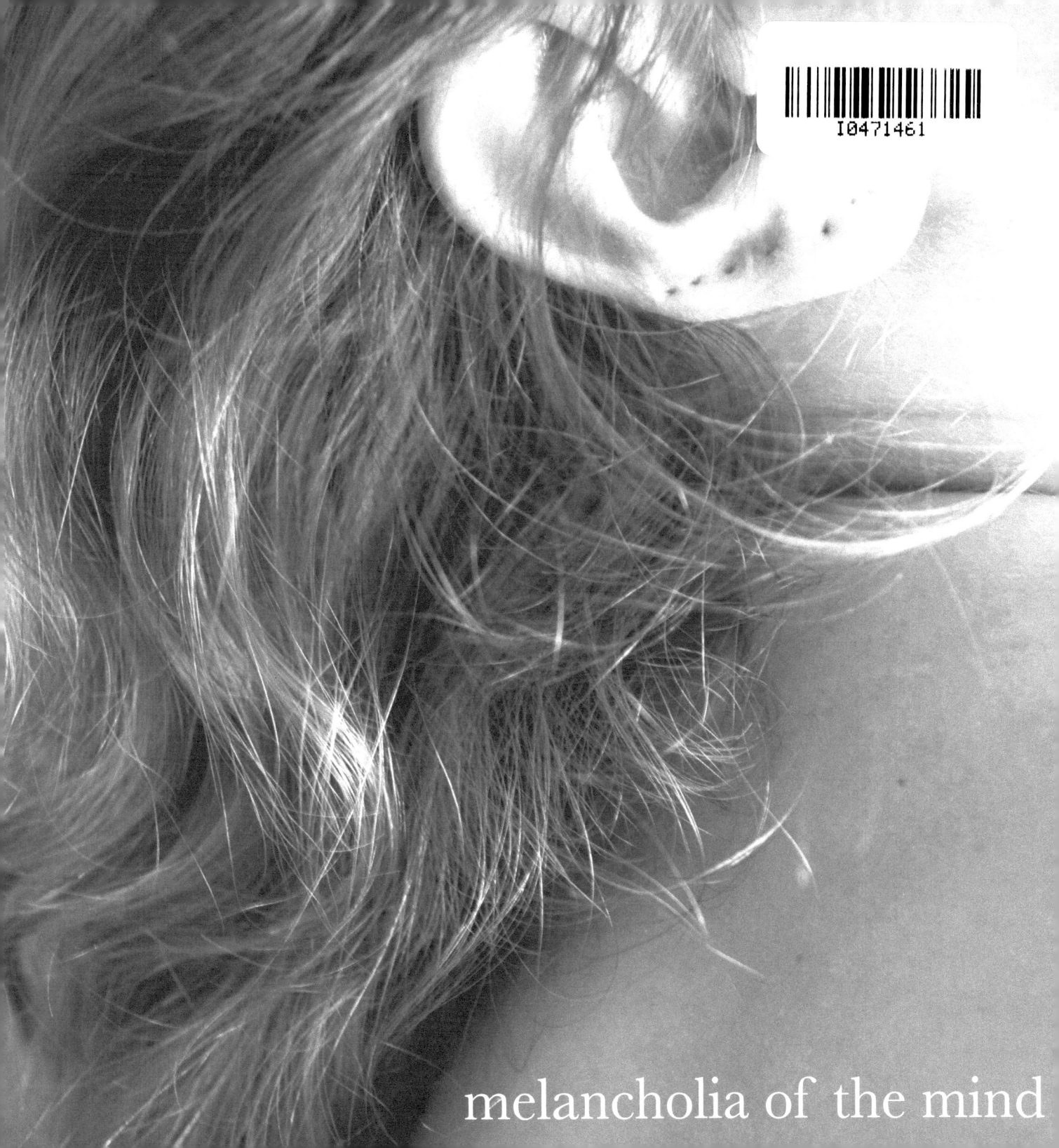

melancholia of the mind

melancholia of the mind
kieran rundle

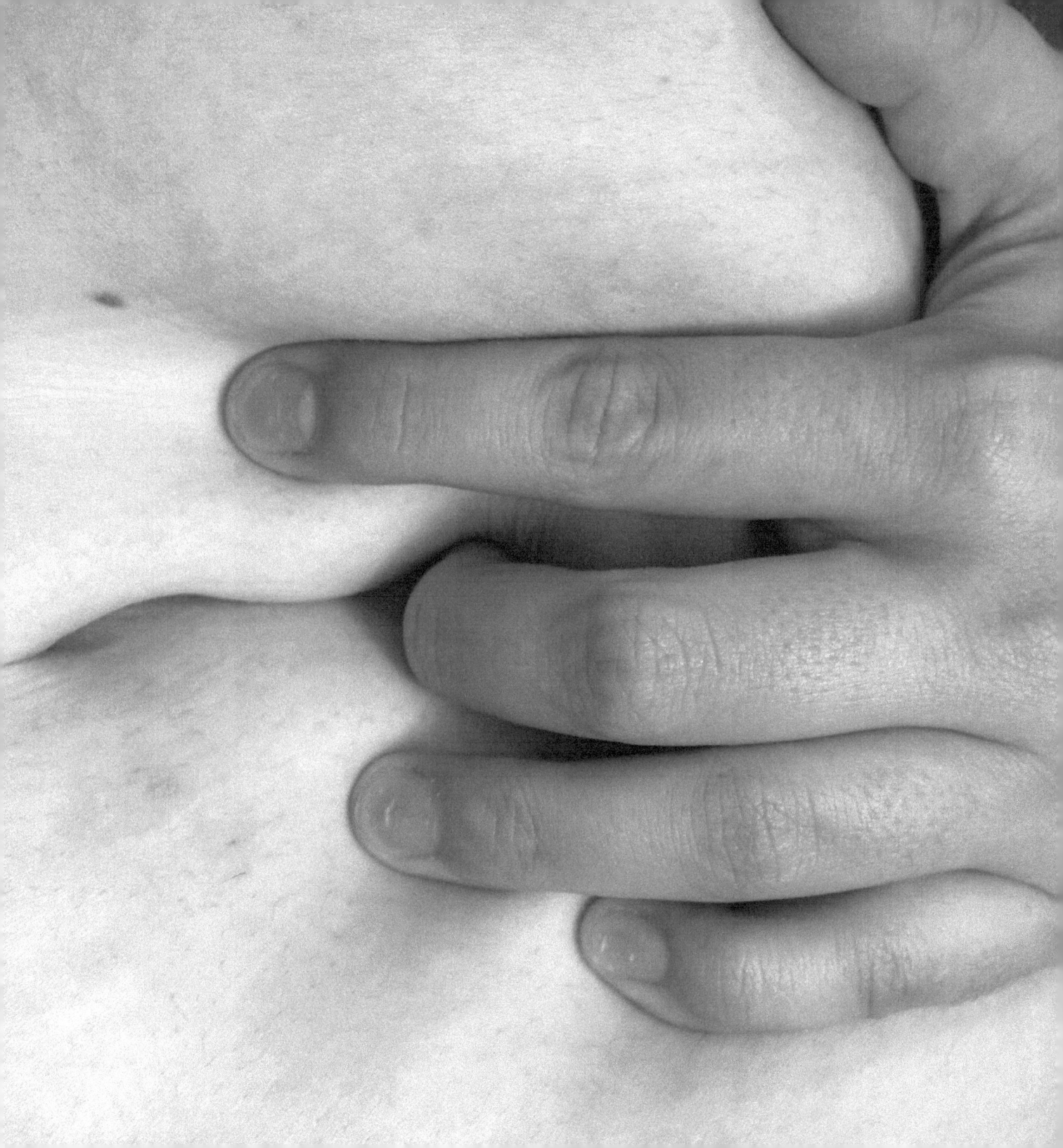

why do the novels about girls like me have to be segregated into their own labeled bookcase?

would i be better if i
cut off my hair,
and my body fit into the cliche of
young adult novels
tucked into the shelves
of the local barnes and nobles?

should i erase the glitter from
my eyes
and the mud from my combat boots
to mold myself
to mimic
the stories
i lose myself in?

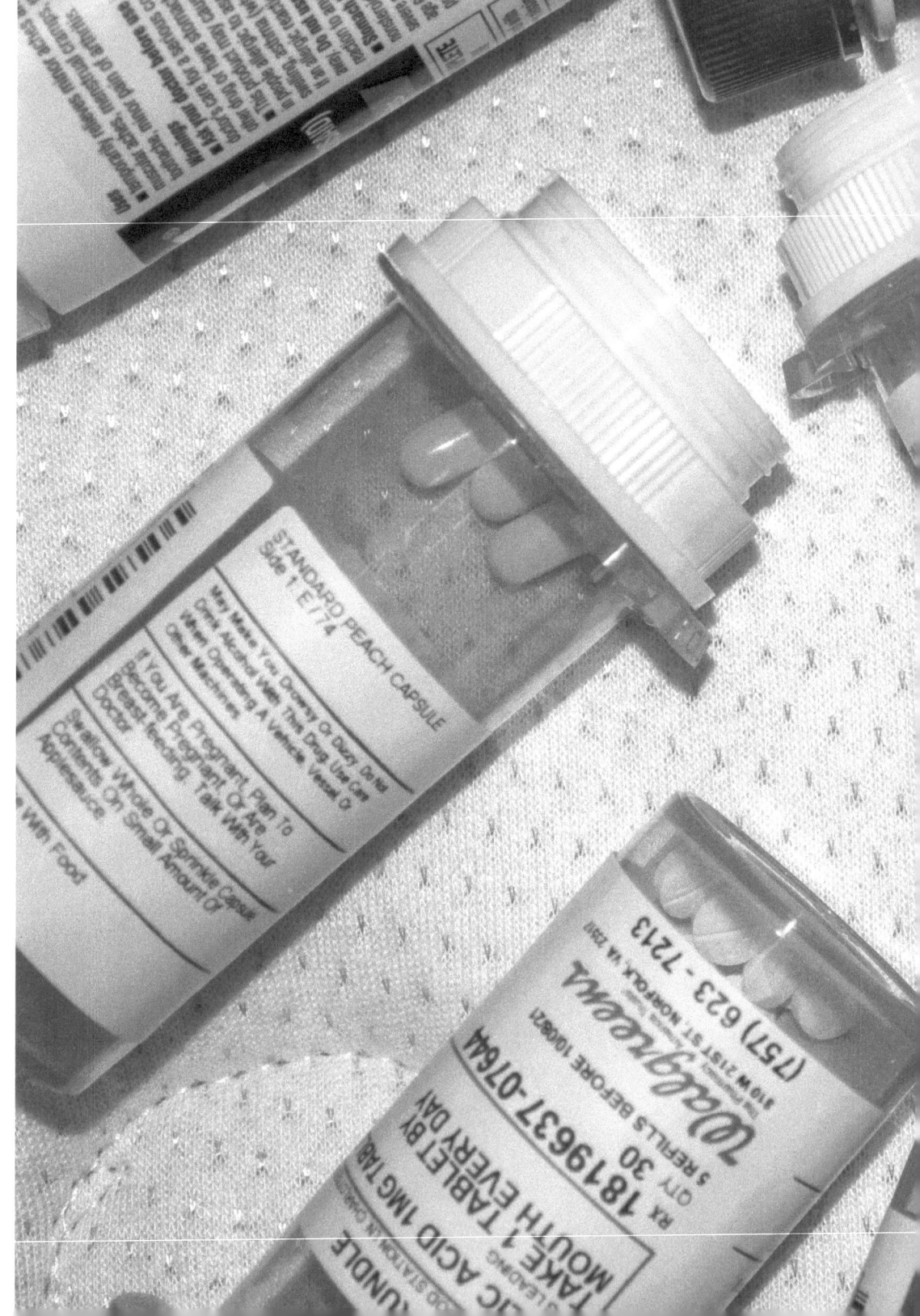

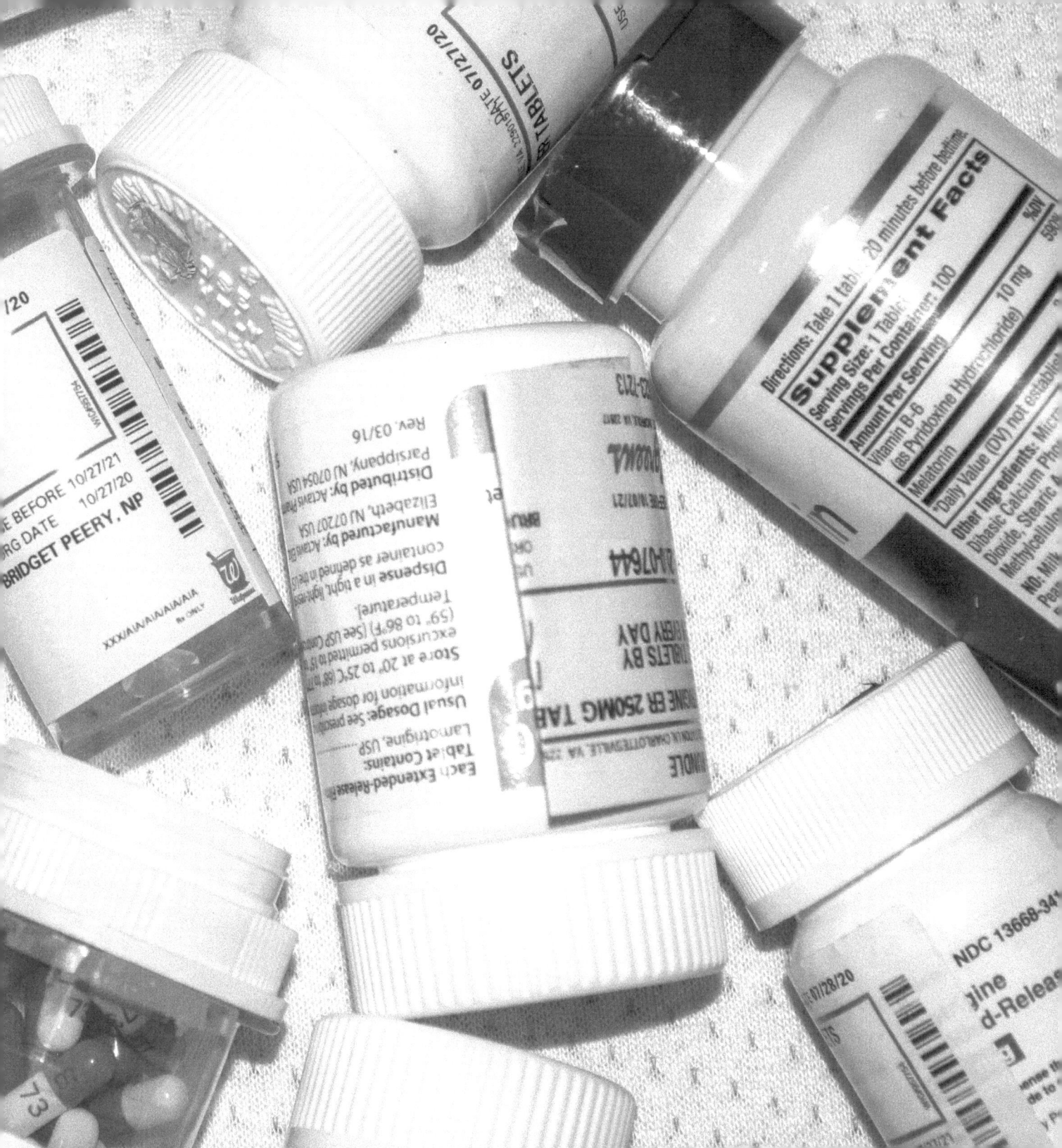

*if the bible says i am wrong
and my country says the
bible is right
then how can i find my
place?*

would i prefer to be
delilah or samson?
should i be distracted by love
or the one to sneak up
and destroy what could have been
on my devil's behalf?

instead of allowing
my mind to answer,
i snip blindfolds
out of the t-shirt
i chose at the last
rock concert
i went to.

i tie them too tight,
until the edges form
indents on my forehead.
the knot tangles
in my hair
and pulls until
my eyes water.

i choose to be blind
instead of waiting
to see
which i become.

*my panic outweighs
my insuperable grief.
the two embark
on an affair
with the sole intent
of disrupting
my medicinal harmony.*

my head
is an old film reel
that clicks as each frame
changes on the projector.

there are only two movies
that still work.

tony and maria-
romeo and juliet-
they go around and around.
they spin until my eyes glaze over
and the sonnets become songs
and the poetry becomes lines.

the two are the same
and i am all four.
i am not a biblical ruin.
that would be too easy-
acceptance and studies
would be conducted.
instead only disdain and
confusion
follow in my wake.

i am hopeless like maria.
i am full of sweet words like juliet.
i am full of romeo's desperation,
and tony's fire.

*should i drink the
silly
over the counter
poison
or try to handle myself
on my own?*

my skin is a map.
my veins
are the roadwork for all
of my desperate failures.

my head
is stuck inside the pages
of poe or chopin.
the rest of my time
i am humming to
sondheim and
evaluating
my exponential increase
of despair.

the words of the classics
keep my frazzled brain
from boiling over
and the last of my sanity
from evaporating.

i cannot come to the
conclusion
that i could be
someone who
escapes precomposed
plots.

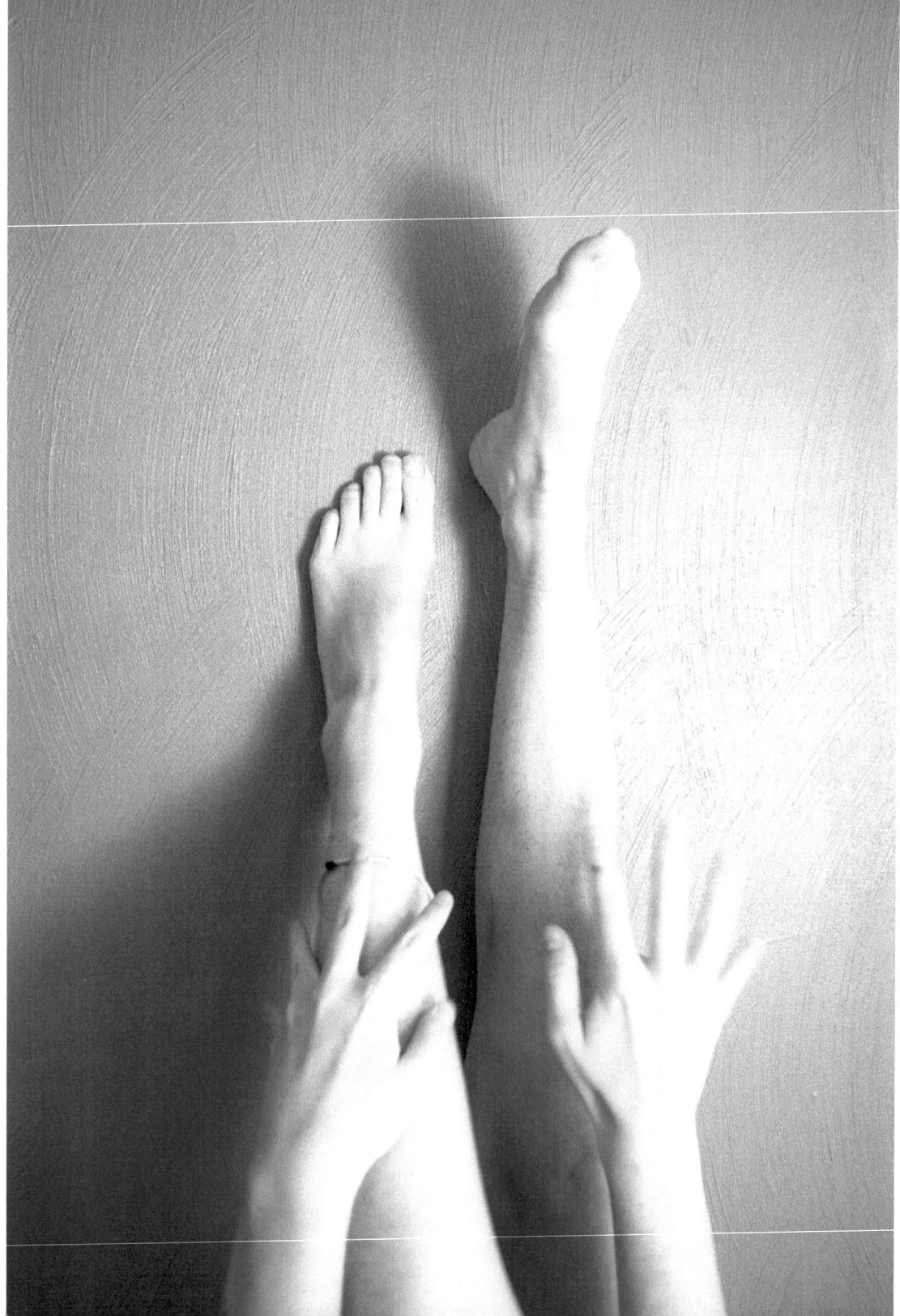

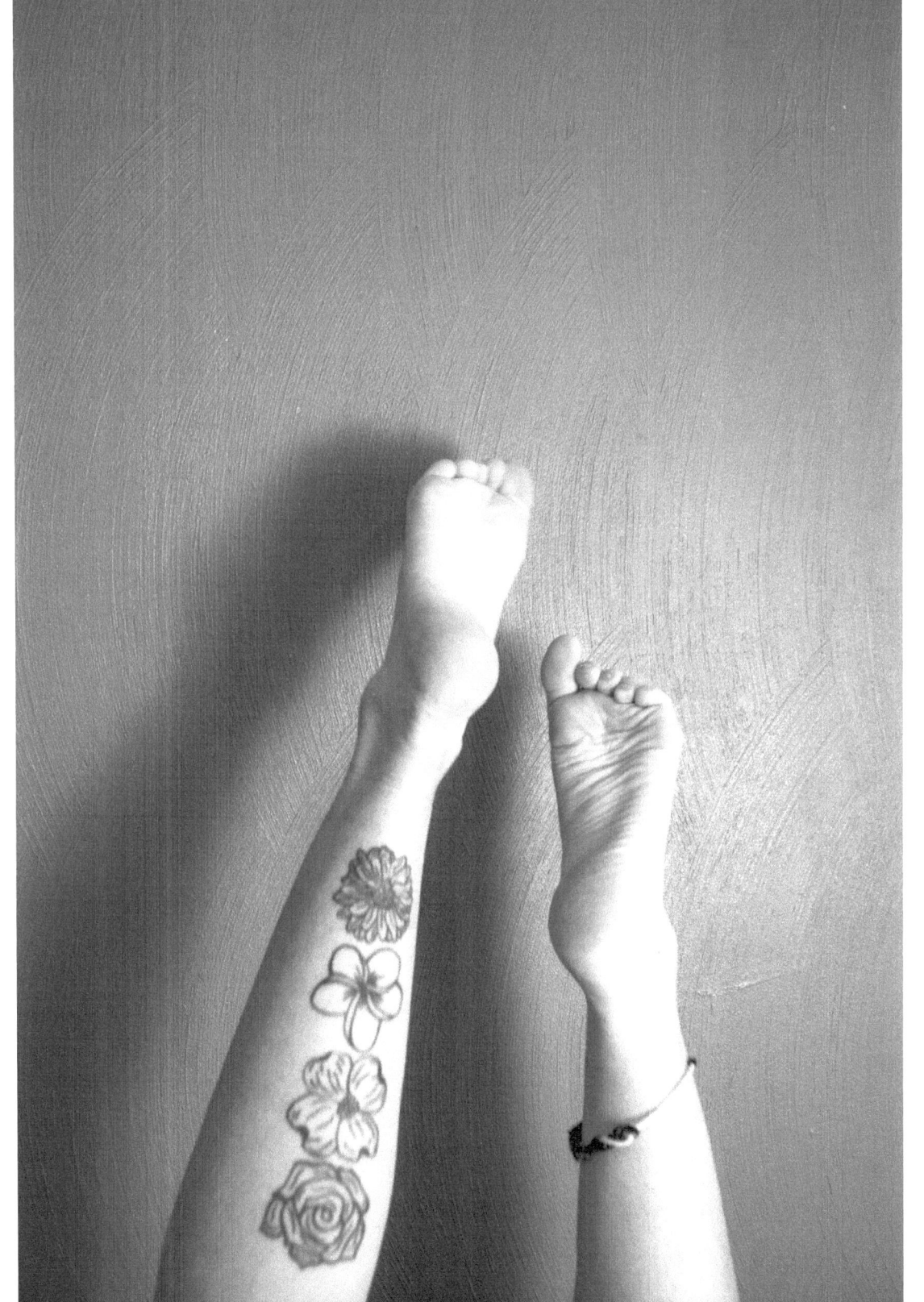

*why can't it rain?
i detest when the weather
does not
coincide with my emotions.*

my analogies all appear
to promptly delve into sorrow
before abruptly ending
with the rest of my thoughts.

instead of moving
i stand still, staring at
the bitter sunlight
that dares me
to be miserable
on such
a beautiful day.

i glare-
wondering why i crave demolition.

i wrap myself
the cocoon of my
cotton bedsheets
in order to fight the
persistent
daily
light.

i block it out,
along with responsibilities
and deadlines.

no one can find me here.
not even myself.

*wounds i bare to the world
are edited.
each detail
is pristinely dedicated
to keep up the web
of complex
simplicity.*

when i first read the iliad in
untranslated latin
i cried.

achilles' heel was not his weakness
it was -
as grade school teachers
weakly mumble-
his close friend
petrocles
who died wearing his lover's
armor for good luck
in battle.

five thousand years went past.
these characters are viewed
as mythology
instead of
respected religious idols.

there is no latin word
for homosexual.
there was no need.
the culture understood
that people would love
whomever they
sought fit.

however,
the language is dead.
petrocles, achilles,
and an empire of stories
are buried beside it.

*even darker than the
melancholia
of my mind
is the needless fear
that consumes my
existence.*

the simplistic concept of
inhaling oxygen
seems far too laborious
for the minimal outcome.

i committed to capitalism
when i could toddle.
i crumpled up papers,
called them cat toys,
and sold them to my parents
for twenty five cents a piece.

i traded health for
results-
on a high
from being overworked
and underslept.

an omnipresent "they"
warned me i would burn out.
to prove them wrong
i dissolved thin into smoke,
not catching flames but evaporating with
them.

t.s. elliot was right all along.

so,
i wander into
emily's attic-
shred the results
from my minimum wage efforts-
and let my lungs
finally rest.

the water is warm.
the air is cold.
the pills are bland.
the room is quiet.

there is no wallpaper-
no carriages.
no armies.
no lovers.

nothing but myself.
seething.
terrified.
relieved?

i make a fort out of pillows
and fill it with open cards
from those
forbidden to enter
the
double layered
locked doors.

each one passes for a gentle
squeeze of my hand.
the memories taste like
lavender and chamomile.
they sprinkle me
with silver
fairy dust,
begging me to fly.

it turns out
i am romeo
all along.

*i put my mattress on the floor.
i take the closet door
off the hinge.
no monsters can
hide in the shadows anymore.*

i remove the blindfold
and brush out the knots
of my hair.
instead of waiting
to see
if someone cuts it
or chopping it off
myself,
i glide into a loose braid.

instead,
i use the scissors
to shred the blanket
i wound so tightly
around me.
forced,
my eyes gave in
to the lemon light.

i refuse to allow
my self affirmations
slip into
semantic satiation.

sitting down
at the pale kitchen table,
sipping a chipped mug of
cinnamon tea,
i embarked on a pile of hardbacks
that waited for me
so patiently.

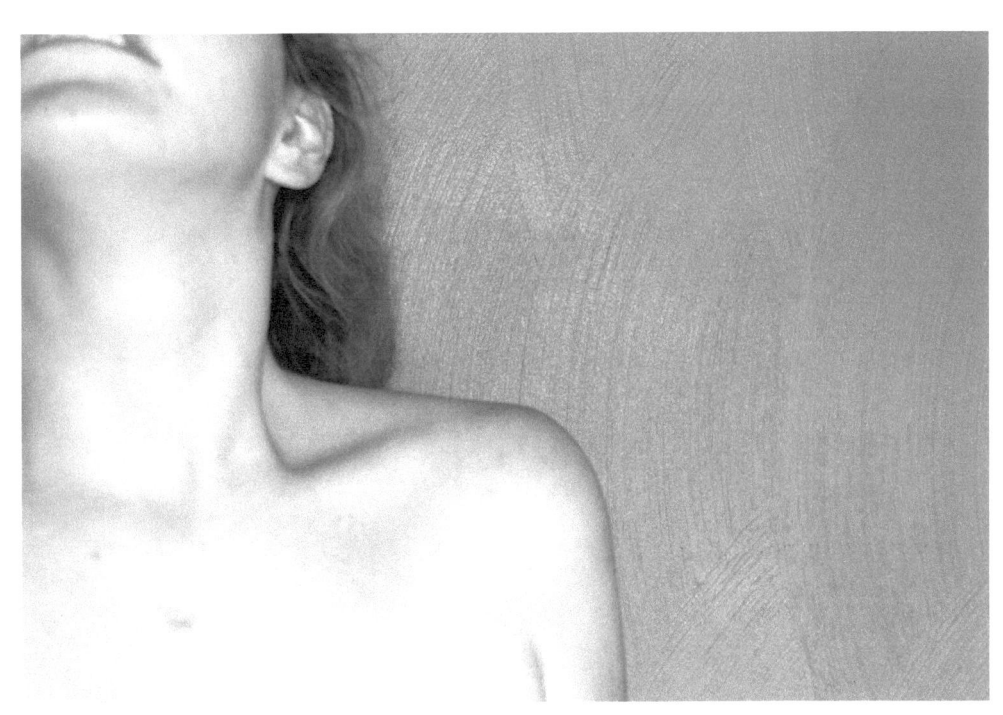

*i absolve
my guilt
for fearing my villains.
i accept that
some offenses
do not warrant
forgiveness.*

i gather the
people who haunt me
without my consent.
we share a moment
in my mind
where i decide to sneak
into barnes and nobles.

i pull all the
stories
off the shelves
about the girls like me.
i mix in classics
for culture.

i slide those
onto the the section
the discount books typically
go.

not because they are
cheap
or unworthy,
but because they deserve
the sparkles of
a center stage
spotlight
and a solo.

i turn off
my flashlight,
wearing ripped tights
and eyeliner.
i smile
at my
satisfactory mischief.

melancholia of the mind

copyright © 2020 by Kieran Rundle

All rights reserved. No part of this book may be reproduced or utilized in any form or by any means, electronic or mechanical, including photocopying, recording, or by any information storage or retrieval systems, without permission in writing from the creator.

For information contact:

Kieran Rundle
www.kieranrundleproductions.com

A Kieran Rundle Production

A Kieran Rundle Production

www.ingramcontent.com/pod-product-compliance
Lightning Source LLC
Chambersburg PA
CBHW051044180526
45172CB00002B/517